T0054292

SOUND – SPACE – SENSE Edited by Detlef Diederichsen, Arno Raffeiner, and Jan St. Werner, with contributions by J.-P. Caron and Patricia Reed, Diana Deutsch and Marc Matter, Tim Johnson, Vera Molnar, Gascia Ouzounian, Matana Roberts and David Grubbs, Paolo Thorsen-Nagel

Sound – Space – Sense

Edited by
Detlef Diederichsen, Arno Raffeiner, and Jan St. Werner

Contents

Inside and Beyond the Eardrum

Detlef Diederichsen: Jan, your work repeatedly emphasizes that sound is not merely sonic, showing that it cannot even be conceived without space and perception. That is the underlying thesis of this volume. In audio events, the connection between these three aspects is often unclear or routinely ignored, but they are constitutive of what is called sound.

Jan St. Werner: We want to disrupt this tacit convention. At concerts or in other situations where sound is central, where there are automated, undiscussed conventions, everyone is expected to know what "sound" is and behave accordingly. You are not supposed to miss anything, but nothing is supposed to escalate either. The key idea behind The Sound of Distance—the festival we organized in and around the Haus der Kulturen der Welt (HKW) in October 2021, which is further developed in the present volume—is that it is possible to break open such conventions and include distances and dynamic spatial relationships in the concept of sound. However, we also show that differentiation is fundamentally possible: the sound of distance, the sound of proximity, the sound of euphoria, and the sound of intensity—but also, for example, how hearing depends on the number of hormones in one's body. You could say that the more people celebrate a sound event together in one place, the less the need to negotiate what sound is. The actual adventure of listening thus disappears, because it's taken for granted that everyone already knows what's going on. Yet these social and cultural arrangements exclude the very thing that makes listening so exciting: the physical, psychological, idiosyncratic processes that are never finished and that vary from person to person. Do we all hear the same thing? Is sound a communal convention or a stable phenomenon that needs to be reconstructed? What are the parameters that allow us to determine what we hear? Here, the relationship to space is central, not only to architectural, Cartesian space but also to psychological, introspective space. Every act of hearing, every sound occurs somewhere, relates to something. These relations imply spatiality; in fact, the spectral movements within sound already delineate a space of their own. There is also the question of positioning: where is a sound located? From which perspectives and in what manner does a sound event present itself?

Arno Raffeiner: For The Sound of Distance, the HKW building and its surroundings were transformed into a resonating body of sound. What does this reveal, and what is explored when you use an entire building as an instrument? What is it good for? What happens in the process?

JSW: First of all, it's a metaphor. Walking around in an instrument would be exciting in itself. Questions arise about proportions and spatial hierarchies. How is it possible to conceptualize a building as an instrument? HKW was transformed into a resonating body in which sounds appeared, but which also itself resonated; we made the Haus and its surroundings vibrate. To what end? What do artists or researchers do with questions that arise from activating the relations between sound and space? Answers to these questions sometimes emerge much later or not at all. Because even if you approach the whole thing scientifically, the person asking the questions does not necessarily have to be the one answering them.

AR: The aim is also to open up a space between sound and sense for experimental arrangements and thought experiments, for listening experiences and reflection. For example, as you put it in your introduction to the festival, Jan: "Is the phenomenon of sound intrinsic to people's constructs of reality?" This raises the further question—repeatedly and variously examined in this volume—of whether we are not unconsciously doing exactly that all the time: using sound and the perception of sound to orient ourselves, to find our way in the world, to decide what we'll do in the first place.

JSW: It is important to shift the focus away from visual attributions, so often at the center of our discourse, and to open up a space of thought and speculation beyond sound. This extends primarily in two directions: on the one hand, it's about the analysis, preconditions, and parameters of a perceptual situation, that is, about fanning out reality and determining whether there are measurable conditions for its construction. Secondly, it's about synthesis: about the interlocking of specific elements that create an event that appears relevant to us. The question of whether this is for pleasure or survival is peripheral from an artistic point of view.

DD: What always comes into play—and this was made very clear by Diana Deutsch's installation at The Sound of Distance—is the danger, or simply the possibility, of mishearing. Deutsch's so-called "phantom words" are based on the phenomenon of two people simultaneously exposed to the same sound source in the same room, yet they hear something completely different. Deutsch's work showed this really well.

JSW: Yes, it allowed you to experience this mishearing while sharing it with others. This is a great experience that has the potential to fill stadiums: everyone hears their own concert and celebrates this un-unanimity with others.

DD: Subjectivity—and this brings us to the notion of sensory perception—is always indispensable to the listening experience. Different programming and elements of experience determine perception and make you relate to listening experiences in a pre-programmed way, so to speak. There is also the fact that the ears work in different ways and, even if the presets were the same or similar, completely different things would emerge. Basically, when two people hear something, it is wholly impossible for them to have the same experience.

JSW: At the festival, I presented an installation with Marcin Pietruszewski that focused on the phenomenon of otoacoustic emissions—sounds produced in the human auditory apparatus—that is, on the ear canal as a space in its own right, in which new sound artifacts can emerge. Interpretations also occur beyond the eardrum, during transmission to the nerve cells. The nerve cells have different sensitivities. There are individual strengths and weaknesses in certain frequency ranges, a kind of color blindness of hearing. The concept of reality, which supposedly provides us with such a stable basis, is, in fact, a completely fuzzy notion. The fact that we can encounter each other in something like "reality" at all is astonishing.

DD: It is a miracle that communication of any kind is possible. And that it enables shared emotional understanding: the fact that several people say, "I'm so moved," and start crying at the same time because they see something on a screen or are deeply touched by music or another art form.

JSW: This is an important question: how is reality achieved? We are wholly plunged into a diffuse theater of groping and guessing—and still, we can generate an event together, and agree that we experience the same thing.

AR: The advent of recording technology was accompanied by the idea that sound can be captured: it can be recorded and replayed at any time, manipulated, and possessed. This idea is very mechanical and is based on something quite opposite to the very nature of sound. It is dynamic, never finished, always in motion. In this sense, this volume is also about a process of forgetting and unlearning, about a different idea of perception.

JSW: When we talk about sound, each aspect subsumed in our discussions may ultimately produce the phenomenon of sound, but they are not individually the phenomenon. There has long been the notion of sound as an object, which was first formulated in the 1950s in such a catchy way that entire schools of music and art sprang from it. The wonderful world of electroacoustic music, which is still productive and fruitful today, embodies the essence of this conception: once we have captured sound on tape, we can do with it whatever we want. We can crawl into it, so to speak, or merge it with other sounds. We can cut it open, insert the tiniest foreign particles, and so on. But that's just an idea of what you can do to trigger an acoustic chain of events: something is played, something is transmitted, something is decoded. The whole thing is basically a complex distraction—a great one, of course, because it's so productive and keeps people from doing more foolish things. At the same time, the achievement of bringing sound to life can also be an asset for art and science. Such experiences produce knowledge. And this always turns the phenomenon of sound into a subject of debate, generating insights that allow for different constructions and interpretations of the phenomenon. Each new insight feeds back into the conception of the whole; you never reach the end.

DD: Of course not. That is also the essence of the work of HKW and of this book series: asking questions, giving impulses, and challenging what seems self-evident. In this respect, we are at the heart of what this institution sets out to do.

JSW: Culture is constantly reinvented through action. It arises precise-
ly from this exchange between people and their need for production
and experience. Regardless of whether it's part of science or part of,
say, enjoyment or consumption. Culture is a constant reconsideration
and questioning, something unsettling with a certain potential for
conflict, perhaps even deconstructive in the sense that references and
connections are fundamentally up for debate. You dissolve them col-
lectively—and put them back together collectively.

DD: This nicely evokes the buzzword "artistic research." I think re-
search on topics like sound is hardly imaginable in a non-artistic way.
You immediately find yourself in a space that is poetic at the very least,
or in a space that opens the doors of perception. Separating the two—
here we are doing research, and there we are doing art—makes no
sense at all in this area.

AR: In this volume, Patricia Reed and J.-P. Caron embark on a specu-
lative exploration of worlds in which the tacit conventions of listening
are suspended. They suggest that hearing organs are not discovered
but created, that they are processes rather than finished instruments.
The human auditory apparatus is constantly retrained and reshaped
by experience, which, by extension, is true for perception in general.
Is it possible to control this process? And would it be sensible to do so?

JSW: By its very nature, artistic research never leads to only one possi-
ble application. After all, the point is to keep finding new combina-
tions, interpretations, comparisons, and connections. The artists
themselves may not be that interested in the consequences of these
discoveries. Nevertheless, they initiate debates and make their find-
ings available to the general public. Pointillism as the precursor of the
pixel, for example, and chance processes in Dada or Surrealism that
anticipated the automated art of artificial intelligence; the smallest
sound particle as the basis of digital sound synthesis, first in the the-
ories of the mathematician Joseph Fourier, later in works by Iannis
Xenakis and Karlheinz Stockhausen. Contributing to the creation of
sensory tools is part of the artistic process; perception changes you,
modifies bodies and actions. It might become possible to train the
hearing organs to no longer perceive certain frequencies, resulting in
the ability to block out unwanted music. Or you may open up listening

areas inaccessible to humans, and after twenty years of solitude, you finally manage to hear the sun. Such modifications are part of a wider debate: what is this thing we call a human being? Does it consist of organs, an organism? Can they be changed or extended? Is it about relations with the outside, or about becoming aware of and uncovering introspective space? This is what Patricia Reed and J.-P. Caron have in mind: we are basically embedded in a practice of world creation. The self is a dynamic system that requires constant redefinition, is in constant exchange with its environment. Sound maps these relationships, in a manner not focused on termination but on movement and change.

Detlef Diederichsen, Arno Raffeiner, Jan St. Werner

Translated from the German by Kevin Kennedy

Vera Molnar, *Hypertransformations*, plotter drawing, ink on paper, 20 × 20 cm, 1974–76

Vera Molnar, *Hypertransformations*, plotter drawing, ink on paper, 20 × 20 cm, 1974–76

Becoming Air:
On Sonic Spatial Metaphysics

The Echo and the Trace

The study of music as an object—as a recorded or written art form, and one that is understood primarily in connection to its formal properties—has diminished or even prevented a wider understanding of music as a spatial practice: as an art form of place, and one that has emerged in dialogue with space.

Music loses its meaning when divorced from the spaces and places in which it happens. Many, if not all, the world's musical traditions developed in relation to specific places, geographies, landscapes, soundscapes, architectures, sites; the translation of these sites through musical migrations; as well as in connection to the social and political spaces that music both reflects and produces.

In Armenia, I listened to musical gatherings as constituted and produced in dialogue with space and place. Adopting a space-based perspective enabled me, for example, to hear a vocal quintet singing sacred music in a fourth-century monastery carved into a mountain not only as transmitting centuries-old music, but as mapping space with the voice. In one chant, four voices accentuated the resonant properties of the chamber through long, sustained tones. A single voice hovered above them, moving slowly in stepwise and ornamental fashion, the voice carving out the acoustic properties of the space as well as its para-acoustic properties—*what* it is about the sound of this space, and this acoustics, that makes it sacred.

The meaning of this architectural-vocal practice was not lost on either the musicians or the audience. Indeed, those categories made little sense in the moment, since everyone was part of a community, or perhaps a communion, created from sound as it emerges in, becomes part of, and transforms a space.

In the same rock-cut chamber, which has a reverberation time five or six times that of most modern interior spaces—which is to say, an acoustic space diametrically opposite to the clean, dry, non-reverberant acoustics described by Emily Thompson in *The Soundscape of*

Modernity[1]—I heard whispers become a mesh of sound that lingered, in which voices freely intermingled, even in their most contemplative, hushed forms.

In this super-reverberant space, sound was so sustained through its reflections that the room seemed to act as a *recording device* for the voice. It captured voices as they circulated inside it, filling the empty chamber where only four grand columns stood beneath stone-cut arches, and where religious symbols and texts were etched onto stone surfaces and walls. As a recording device for the voice, this sacred site captured the traces of sounds that people made, sounds that were ultimately absorbed into—and thus became part of the very materiality of—the chamber. Through these sonic inscriptions, the chamber also captured a trace of those human souls.

A monastery thus becomes a space that is created of and with sound: it is a repository not only of the religious traditions that developed there—traditions that hid from persecution by sheltering inside a mountain—but, equally, a repository for souls as they were once manifested in sound.

Entering the Air

A spatial metaphysics of sound shaped the work of Terry Fox (1943–2008), an artist who, starting in the late 1960s, developed a practice in which he made sound-producing actions continuously for hours or even days inside various architectural spaces (a ruined church, an abandoned attic), with the idea that the movement of sound inside those spaces would transform them.

For Fox, the idea of transforming a space through sound was not metaphorical but literal. Although he created these works privately, specifically out of sight and earshot of an audience, he nevertheless hoped that people who entered a space after he had completed his sonic actions would perceive it as having changed. He said, "I tried to

1 Emily Ann Thompson, *The Soundscape of Modernity: Architectural Acoustics and the Culture of Listening in America, 1900-1933*. Cambridge, MA: MIT Press, 2004.

activate [...] space in such a way that a residue would exist afterwards, just a feeling, an intangible thing [...]. And it worked."[2]

Just as the categories of "audience" and "performer" seem inappropriate in describing musical encounters in the cave-monastery in Armenia, the concept of "performance" seems inadequate in describing Fox's practice. Fox, who believed that "all sound is sculpture,"[3] *himself* arguably formed a communion with the spaces he activated through sound. He used sound to become one with the air and the architecture around him, producing "sculptures" through which the body, air, and architecture were conjoined in the common realm of vibration.

During the time he developed this unique approach to sonic sculpture, Fox had a desire to levitate. He wrote of his 1970 *Levitation Piece*—which took place inside a room whose floors and walls he covered with bright, white paper such that it produced a sense of buoyancy—that "I lay for six hours [...] trying to levitate [...] I was trying to think about leaving the ground, until I realized I should be thinking about entering the air. For me that changed everything, made it work. I mean, I levitated."[4]

This simple but transcendent shift in perspective—to think not of leaving the ground but of "entering the air"—embodies the kind of perceptual reorientation needed for experiencing architecture as comprised of vibration; to experience one's body as a source and medium of vibration; to become a channel; to become entangled with architecture and space through sound.

For *Levitation Piece*, Fox himself lay on a bed of earth he had gathered from the freeway. He wrote, "When the freeway was built, the earth was compressed, held down. You can conceive of it expanding when you release it rising, becoming buoyant. Of course, it's physically

2 Terry Fox, *SiteWorks: San Francisco Performance 1969–85* (2000), https://siteworks.exeter.ac.uk/items/show/17, accessed July 6, 2022.
3 Matthias Osterwold, "Terry Fox: Economy of Means—Density of Meanings," in Terry Fox (ed.), *Works with Sound/Arbeiten mit Klang*. Berlin: Kehrer Verlag, 1998, pp. 17–30, here p. 17.
4 Terry Fox, "I Wanted my Mood to Affect their Looks," *Avalanche*, no. 2 (Winter 1971), pp. 70–81, here p. 71.

impossible. But for me the mere suggestion was enough. I was trying to rise too."[5]

Hant Variance

In Paris, I attended an open studio by Sabisha Friedberg, an artist who engages esoteric phenomena, including the phenomenon of levitation, which she has explored in connection with both mystical and scientific discourses (discourses which were not always so distinct).

The final movement of Friedberg's three-movement multichannel composition *Hant Variance*, which I heard over an eight-channel system that Friedberg had tuned for hours, features low-end bass tones that she "recorded live with a subwoofer configuration that allowed for rapid directional shifts." She writes, "Sustained pure tones shift minimally and the allocation of sound engenders a sense of aural disorientation. This landscape, with the premise of summoning a new phantom or haunted sonic space, exists in an interstitial, albeit present zone."[6]

In experiencing *Hant Variance*, I had a feeling of profound but precisely controlled dislocation. The low-end tones were somewhere, but it was impossible to say where that "somewhere" was. They permeated the space while also being located "in place"—and were simultaneously unplaceable, residing in an interstitial zone. The low-end tones were still and sustained, yet spinning and alive. As sounds I could locate inside my body and simultaneously outside it and away from it—moving, in motion—they disrupted my sense of my body's dimensions, and troubled the distinction between my body and the environment: those realms, and the "things between them," began to overlap.

To my mind, *Hant Variance*, and Friedberg's work more generally, belongs to a category of sonic practice that occupies a space between acoustics (the physical behavior of sound and vibration), psychoacoustics (the psychology of hearing), and sonic metaphysics: engaging the nature of reality through sound and sonic experience.

5 Ibid.
6 Sabisha Friedberg with Peter Edwards, *The Hant Variance* (February 15, 2015), https://www.sabishafriedberg.net/projects/category/LP, accessed July 7, 2022.

feed

A sonic metaphysics might unfold ideas of time and space; of materiality and energy; of object and event; of being and becoming. It might invite us to contemplate the nature of "things"—whether and how matter can become energetic; where the line between the material and immaterial lies; and whether that line, or that space, can be activated through sound.

The Inversion of Everything Solid

In his notes to The Sound of Distance, Jan St. Werner writes that "Sound doesn't imply an ideal observational position. We cannot claim that the sound of an instrument is an object with sharply drawn contours, which from a certain perspective becomes ideally graspable in its shape, statement and purpose, and which presents itself as an absolute. On the contrary, sound is incompleteness. It is the essence of the porous, the corrupt, the inversion of everything solid. As soon as sound appears, it resonates and vibrates in complex relationships with its environment. Sound *is* its environment."[7]

Sound, St. Werner suggests, is inextricable from environment—and it is its condition of porousness, its state of incompleteness, its status as the antithesis to that which is solid—that makes it such. Through vibration and resonance, sound sets that which appears to be solid into motion. Sound reveals solid matter to be vibrant. It both embodies and produces the "vibrant materiality" that, as Jane Bennett has suggested, connects human and nonhuman worlds.[8]

A feature of sound that has been contemplated for centuries, yet remains poorly understood, is that it is both "corrupt," as St. Werner writes, *and corrupting*. Writing in the early seventeenth century, the English natural philosopher Francis Bacon suggested that "Audibles" were distinguished from "Visibles" in that "Audibles" (sounds) had the power to disturb a medium like water or air, whereas "Visibles"

7 Jan St. Werner, "Beyond the Sweet Spot: Questions about Sound, Distance and the People In Between," in Arno Raffeiner (ed.), *The Sound of Distance: New Conceptions of Music, Space and Architecture*, program booklet. Berlin: Haus der Kulturen der Welt, 2021, pp. 9-13, here p. 11.

8 Jane Bennett, *Vibrant Matter: A Political Ecology of Things*. Durham, NC: Duke University Press, 2010.

(light) did not.[9] In contrast to light, sound could disturb a medium and produce changes in it—in other words, "affect" and "corrupt" it.[10]

It is this affective capacity of sound that perhaps most distinguishes its potential, yet remains largely mysterious. In *Sonic Warfare*, a treatise on sound and affect, Steve Goodman argues for a vibrational ontology of sound that "delves below a philosophy of sound and the physics of acoustics toward the basic process of entities affecting other entities."[11] While Goodman's study makes a critical intervention into the aestheticist and formalist bent of sound studies, a recognition of sound's capacity to "affect other entities" has imbued Western philosophies of sound since at least the time of Aristotle. As early as 350 BCE, in Aristotle's *De Anima (On the Soul)*, we can find both a conception of sound-as-movement, and of sound *as moving and affecting*.

In contemplating the production *as well as the perception* of sound, Aristotle regularly referred to movement, describing sound as "a kind of movement of the air," and as "a movement of that which can be moved."[12] The historian of philosophy Mark Johnstone reflects on the spatial conceptions of sonic movement in Aristotle's writings, remarking that: "The air that has been moved is said to 'reverberate' inside a hollow object, to 'bounce' back, to 'rebound', to be capable of 'dispersing', to 'vibrate.'"[13]

However, it was not only sound's capacity to make the material and the immaterial ("the void") move and vibrate that was of concern to Aristotle, but also the *qualities* of that movement and its effects upon the receiver—what we might imagine as a kinetics of the soul. It is the nature of those kinetics that have evaded Western philosophers and physicists for centuries, and for which we must turn to musicians

9 Francis Bacon, *Sylva Sylvarum; Or, a Natural History in Ten Centuries*, 10 vols. London: William Rawley, 1626.

10 Gascia Ouzounian, *Stereophonica: Sound and Space in Science, Technology, and the Arts*. Cambridge, MA: MIT Press, 2021, p. 7.

11 Steve Goodman, *Sonic Warfare: Sound, Affect, and the Ecology of Fear*. Cambridge, MA: MIT Press, 2010, p. 82.

12 Aristotle, *Aristotle On the Soul; Parva Naturalia; On Breath*, trans. W. S. Hett. Loeb Classical Library. Cambridge, MA: Harvard University Press, 1957, p. 117.

13 Mark A. Johnstone, "Aristotle on Sounds," *British Journal for the History of Philosophy*, vol. 21, no. 4 (2013), pp. 631–48, here p. 634.

and mystics—to those who used sound to "enter the air"; and to enable others to "rise."

As Permeable as a Membrane

In his own practice, St. Werner resists conceptualizations of sound-as-object and the idea of a fixed or idealized listening perspective by developing a sonic and musical language rooted in dynamism, movement, and relationality. In *Squares Will Fall* (2021), for example, three acrobats perform a choreography with three loudspeakers suspended over a circus stage, each speaker transmitting one channel of a three-channel composition. The acrobats dance with the loudspeakers, hang and spin from them, and swing through the air with them, thereby mixing the sound elements—St. Werner writes, by "animating the speakers in real time."[14] In contrast to multichannel works in which an engineer "diffuses" a composition over a fixed set of loudspeakers, the acrobat-mixers collectively *dance* and move the music into existence, the movements of their bodies in space inextricable from the music's trajectory and unfolding.

With the collaborative project *Robodynamic Diffusion: RDD*, Werner—together with Michael Akstaller, Oliver Mayer, and Nele Jäger—explores the kinetics of sonic space by manipulating the movements of a "sound robot": a roving loudspeaker whose movements can be remotely controlled, and whose speakers can be made to point in any direction. The movements of the sound robot inside an architectural space, they write, "set[s] the environment into vibrations, thus influencing the sound result [...]. The venue itself becomes part of the instrument and is actively involved in the composition: a transformation of space into sound."[15]

RDD makes sensible the idea that, as sound sets an environment into vibration through reflections, reverberation, and resonance, vibrating space also influences the movement of sound inside

14 Jan St. Werner, *Squares will Fall* (2021), see the Ural Industrial Biennial of Contemporary Art Festival website, https://uralbiennial.ru/en/we/artists/person12-jan-st-werner, accessed July 7, 2022.

15 *Robodynamic Diffusion: RDD* (2021), see the Ural Industrial Biennial of Contemporary Art Festival website, https://uralbiennial.ru/en/we/artists/person368-robodynamic-diffusion-rdd, accessed July 7, 2022.

it. Sound both affects and is affected by its environment, enmeshed in a feedback loop whereby the interrelations of sound and architecture are dynamic, complex, intersecting, overlapping, and impossible to disentangle.

The sonic sensibility of flux that characterizes St. Werner's practice is in sharp contradistinction to Western art-music concert traditions in which musicians and loudspeakers occupy fixed positions on a stage, "projecting" sound outwards from those positions. In these traditions, multichannel compositions typically use volume control or filtering to create an *illusion* of spatial movement. By contrast, projects like *Squares Will Fall* and *RDD* are predicated on the *actual* movement of sounds in space. *RDD*'s creators stress that what is most important is not the robot itself, but "the displacements it can affect: controlled disorientations and sensory redirections [...] [producing] a sense of space that is multi-perspectival and responsive."[16] Listeners, too, are imagined as active collaborators, invited to "displace themselves from their passive position as audience-receivers into a system of feedback and response as listener-collaborators."[17]

In its desire to "affect displacements" and release music from its fixed perspectives, St. Werner's practice shares an impulse with that of Edgard Varèse, who, before the technologies existed to realize it, imagined a "spatial music" "made of sound set free."[18] St. Werner's anarchic aesthetics of sonic dynamism extends not only to the interrelations of sound and space, however, but also to the interrelations between bodies and spaces. He not only seeks a different degree of freedom to sound and to music, but also to *people*, whose active participation he considers vital: "One must be consciously present, constructing one's own experience and thereby experiencing its constructedness in real time. It's about staying in motion, pulsating and becoming as active and permeable as a membrane," he writes.[19]

There is a politics to this aesthetics of movement, fluidity, and flux. If we understand space and place as not-fixed, not-static, re-

16 Ibid.
17 Ibid.
18 Edward Downes, "Rebel from Way Back: Varèse, Composer of Electronic Works, Likes Music that Explodes in Space," the *New York Times*, November 16, 1958, X11.
19 St. Werner, "Beyond the Sweet Spot," p. 13.

sponsive, changing and changeable, we have a different sense of its potential futures—*what can happen there*. And, if through sonic displacements and disorientations we experience ourselves as permeable and corruptible, as being both affected and affecting—as active participants and collaborators in the production of space—we too have a different sense of our own potentials, our own possibilities of being.

Acknowledgments
I'm grateful to Jan St. Werner, Arno Raffeiner, and Detlef Diederichsen for their invitation to contribute to this volume, and to Jan for the sonic travels; to Sabisha Friedberg for generously sharing her music and artistry; and to Samantha Dieckmann and Gerard Gormley for their helpful reading.

This essay was supported in part by the European Research Council (ERC) under the European Union's Horizon 2020 research and innovation programme, as part of the project "Sonorous Cities: Towards a Sonic Urbanism" (grant agreement No. 865032).

Vera Molnar, *Colonnes*, plotter drawing, ink on paper, 23 × 32 cm, 1985

Listening to Unencoded Worlds

PART 1
Organs and World Versions

You are not just sitting in a room but located in a world.

The stable morphology of the ear throughout millennia is offset by its unstable versioning, conditioned by worlds. Encoded in a particular way, the worlds within which one listens shape the organization of sense, such that worlds can be said to construct organs in their likeness.

While worlds, as sheer models, neither emit nor transport sound, there is no understanding of listening without a model-world that orients what organs of listening do.

Organs of listening are not discovered, but crafted.
BUSY AIRPORT FIELD RECORDING
CALM, DRONEY ELECTRONIC SOUNDS

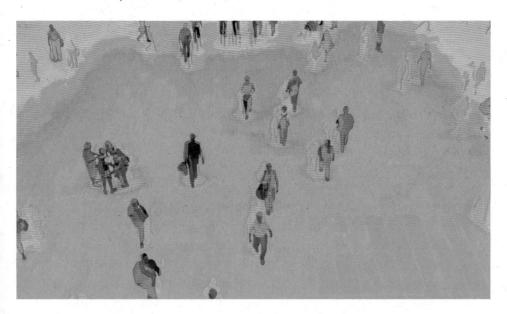

Listening is an activity of localization, a way of positioning the self and selfhood in relation to the contents of a world in space and time.

Even when shared, it is a personal experience enabled by impersonal conditions, which collapse a false estrangement between intimacy and distance.

One closes one's eyes and listens. The world does not recede. The sounds carry their physical referent in terms of sonic source, place, relative distance, and general ambiance. One cannot close one's ears as one closes one's eyes. Nor must one choose between *hearing* and *feeling* vibration.

LOUD ELECTRONIC SOUND MASHUP WITH AIRPORT
FIELD RECORDING
The absolute soundproofing of experience is impossible.
ABRUPT SILENCE

And yet, in another sense, worlds *do* recede, because they can be encoded anew. Worlds are made from the remaking of ruins, through the recrafting of conceptual and material artifacts. The receding of a world transpires as a shadow that is cast from the perspectival frameworks of an otherworld which reconfigures concrete practices of inhabitation.

DISTORTED ORGAN SYNTHESIZER MUSIC

This is the political valence of worlds: the capacity to localize, differentiate, identify, and organize entities within them. Worlds often give the semblance of unchangeable fixity, yet this is but a symptom of the naturalization of sense. Encoding does not equate with axiomatization. If a world fashions organs of listening adapted to its encoding, how can organs participate in the receding of a world as a movement of *organic inadaptation*, a seeking to render unencoded worlds amenable to sense? Can one listen from the unencoded conditions of an otherworld?

PART 2
Localization in a No-Space World

Imagine for a moment what it would be like to inhabit a no-space world. This is an echoless world, with only formless entities and no ground. Distance and proximity only exist on a temporal spectrum.

This is what Peter Strawson modeled as a pure auditory world—
a model in the form of a speculative inquiry.[1]

While embedded in a purely auditory world, is it possible to recreate
the empirical conditions of localization that are available to us in the
frameworks of three-dimensional space?

The parameters are strict. Without the spatial properties of gaps
or intervals, the objective is to recreate localization from experiences
purely constituted through sound. There is no body in an entirely au-
ditory world, because any "body" implies volume, and thus a spatial-
ized manifestation.

In this experiment, your physical presence is identified by a
Master Sound. Each "agent" in this auditory world possesses such an
identifying sound.

Your Master Sound functions like a radio dial.

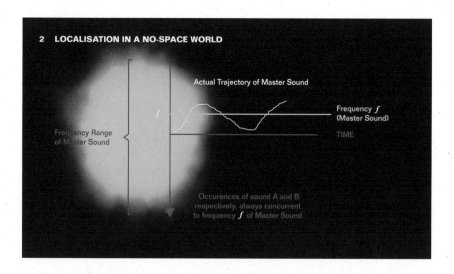

1 Peter E. Strawson, "Sounds," in Strawson, *Individuals: An Essay
 in Descriptive Metaphysics*. London: Routledge, 1959.

DISTORTED RADIO SCANNING FOR SIGNALS

It scans the available range of frequencies from bass to treble. As a radio dial, from time to time your Master Sound encounters an "other"—a sound that is not part of your own Master Sound spectrum.

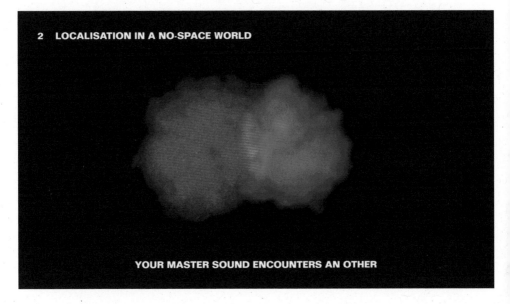

2 LOCALISATION IN A NO-SPACE WORLD

YOUR MASTER SOUND ENCOUNTERS AN OTHER

A conundrum arises in this no-space restaging of experience. In such a world, shorn of spatial "place" without the separability between figure and environment, how it is possible to reidentify particular items? In our familiar world, you enter a room. You see an object. When you go out of the room and then return, you recognize the object as the *same* object. In other words, how can one differentiate oneself from their surroundings without space? Is there a non-solipsistic consciousness in such a world?

The only available criteria at our disposal for reidentification in a no-space world is the coincidence of a particular frequency within our Master Sound and the reappearance of a sound in the same "place" where "place" has no correlation with three-dimensional space. Is this enough to construct an analogue in the no-space world?

The activity of worldmaking begins with a commitment to suspend given referential frameworks.

PART 3 – Interworldly Frictions

TYPEWRITER

"'Can't you see what's before you?'

TYPEWRITER WITH DRUMMING

Well, yes and no.
 I see people, chairs, papers, and books that are before me, and also colors, shapes, and patterns that are before me.

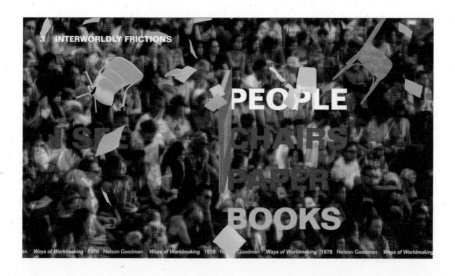

CHAOTIC PIANO SOUNDS

But do I see the molecules, electrons, and infrared light that are also before me? [...]

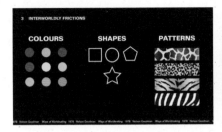 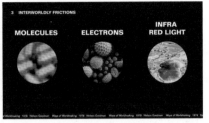

I see only parts of the latter comprehensive entities, but then I also see only parts of the people, chairs, etc. And if I see a book, and it is a mess of molecules, then do I not see a mess of molecules? But, on the other hand, can I see a mess of molecules without seeing any of them? If I cannot be said to see a mess of molecules because 'mess of molecules' is a sophisticated way of describing what I see, not arrived at by any simple look, then how could I be said to see a magnet or a poisonous mushroom?'"[2]

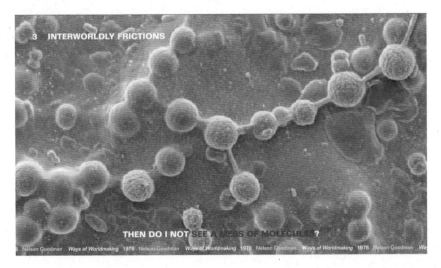

2 Nelson Goodman, *Ways of Worldmaking*. Indianapolis, IN: Hackett, 1978, p. 71.

There are diverse, and sometimes incompatible ways of seeing, describing, and knowing a world and its contents. Worldmaking corresponds to the use of frameworks through which to gain partial access to the real.

> The sun always moves.
> The sun never moves.
> FIELD RECORDING OF FOOTSTEPS

Imagine having access to two different worlds both of which are true according to their referential frameworks. Truth, in this scenario, is purely relative to its internal logics. The frictions that can arise through incompatibility occasion a rare visibility, a stripping of model-worlds unto themselves of their given status, disclosing them as abstract X-rays.

> DISTORTED X-RAY SOUNDS
> FIELD RECORDING OF FOOTSTEPS

On the other hand, it is possible to inhabit plural worlds simultaneously in the experience of listening to music. One is engulfed in the ocean of sound to the point of forgetting one's immediate surroundings. But that is not only an annulation of one's surroundings and of the difference between oneself and the other; it is also the projection from one's immediate empirical world to a different set of coordinates. In listening to music—as *structured sound*—the functions of localization are fully operative, albeit in a different world, as if one could simultaneously inhabit two different worlds, two different sets of parameters of experience and localization.

> "Art negates the categorial determinations stamped on the empirical world and yet harbors what is empirically existing in its own substance. If art opposes the empirical through the element of form—and the mediation of form and content is not to be grasped without their differentiation—the mediation is to be sought in the recognition of aesthetic form as sedimented content."[3]

3 Theodor Adorno, *Aesthetic Theory* (1970), trans. Robert Hullot-Kentor. New York: Continuum, 2002, p. 5.

The inner space of art—specifically that of music—elicits a different sense of space, while taking from its outside some of the forms of its determination. Each world is as permeably interconnected as the limits between one-and-other, identity and difference, event and memory, antecedence and consequence...

PART 4
Temporal Placing and Indexical Time-Points

LOOPING TECHNO TRACK

Let us return to the problem of constructing parameters that enable the experience of localization in a purely auditory, no-space world.

The constructed sound object would have to exhibit its own indexicals—moments in the trajectory of the form that can be used as points of reference for listening, that is, *indexical time-points*. Time is then given referential structure through sound. A sound event is created that says "here things change," "remember this," like pebbles tossed on the ground to guide the way.

But sound may suspend time as well, by refusing to provide any indexicals. Rather, an undifferentiated time may be offered to the listener through which to float.

4 TEMPORAL PLACING / INDEXICAL TIME-POINTS

In a world indexed temporally, sonic ambiguity may contain thresholds of recognizability. But what are the thresholds that make the indexical time-points of an extended sound object recognizable, and what time scales stop short of being points of reference for a human listener? What are the thresholds of temporal expansion and contraction that still allow for sustained recognizability?

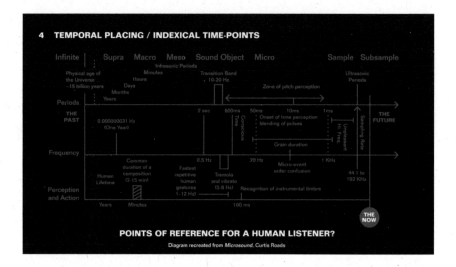

With digital time-stretching, it is possible to extend a certain sound to indefinite lengths. This gradual extension of an encoding reconfigures the once fully recognizable sound object into something alien and eerie, while extending the size of our memory buffer such that our specious present is unable to follow.

The possibility of encoding planetary sensitivities is entirely entwined with this problem: in their dramatically stretched temporal registers, chemical, material, and geological temporalities push the limits of recognition.

PART 5
Organic Inadaptation

An organ is something that is *sensitive* to a specific range of inputs. The range of these possible inputs varies across creatures, technologies, and entities.

pure

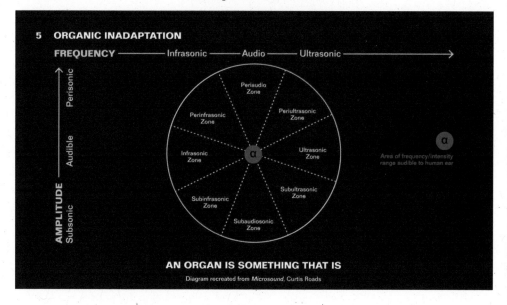

FIELD RECORDING OF BIRDS, LOONS

Because the encoding of a world is always incomplete, every world contains a surplus of possibilities that standard encodings dictate insensitivity to, namely the unencoded. Similar to Alain Badiou's idea of the inexistent, the unencoded belongs to an encoded world as a minimally weighted entity or sense-object—something that is acoustically present but cannot be evaluated according to the encoding of the existing world configurations. The becoming encoded of the unencoded brings into maximal intensity that which was previously unrecognizable.

Abductive realism entails becoming sensitive to unencoded entities that actually exist—despite being eclipsed by conventions of encoding—and charting consequences upon otherworlds from the maximization of their appearance. In this way, we can also trace the relationship between *syntactic*, or structural procedures of encoding, and *semantic*, or meaning-making relations to reality.

Badiou's name for that which is able to perpetuate the consequences of the maximal appearance of the unencoded is "body."

FIELD RECORDING OF WATER, WAVES

And that which is able to detect and treat specific points of resistance imposed by the world-as-previously-given to the advent of the world-as-begotten-by-the-unencoded, is "organ."

Organs are made by grasping the consequences of a change in worlds. To reiterate our question: how can organs of listening be constructed that are sensitive to new encodings that constitute an otherworld of listening?

SIMULATED INTERPRETATION OF *HYMNEN*

From music, we can trace such a process through Karlheinz Stockhausen's *Hymnen*.

> In this world conditioned by encodings of intellectual property, we are unable to play the real Hymnen.

National anthems serve as the raw material for *Hymnen* [Anthems], as they provide a familiar index for listeners whilst calibrating the sensitivity of their organs for unfamiliar electronic sound manipulations.

Hymnen thus localizes that which is unencoded via the maximally recognizable encoded anthems.

By the end, the unencoded reaches its maximum degree in what is called the *Hymunion in Harmondie under Pluramon*, an abstract tapestry of found and electronic sounds that is treated as a new anthem, shedding the need for the recognizability of the existing anthems.

By localizing the different sound manipulations in the familiar structure of anthems, *Hymnen* provides us with a guide through which we can gradually construct the auditory means of detecting the emergence of the new, the unfamiliar, and the unencoded.

SMASHING CYMBALS

Even though *Hymnen* paves the way for the appearance of a certain form of the unencoded, it displays a mode of political conservatism. By upholding the hegemonic encoding of nation-state semantics, it implicitly perpetuates their indexical identities and logics of configuration, that is, the parameters through which the entire contents of the globe has been carved up, bordered, and separated. This encoding is entirely at odds with planetary conditions, which reveal other spatial and temporal frames of reference that are not only plural, including nonhuman entities, but far more dimensional than the flattened spatiality of the current geopolitical configurations. The crafting of orientation within a space that recognizes such pluralities is dependent on the construction of organs that are sensitive to its multi-scalar dimensionality.

You are not just located in a world, but many worlds at once.

"A strange woman had entered the room and began to sing"

Marc Matter: I'd like to talk about "musical illusions," your discovery of "phantom words," and their connection to music and composition. How did all this evolve, and what interested you about musical illusions in the first place?

Diana Deutsch: As a child and teenager in the UK, I had always been fascinated by visual art and specifically illusion in art—how artists can deliberately distort perspective. They play with color contrast; they create drawings that give impressions from very little information, and the mind fills in the gaps. But my strongest interest was in music. From a very early age, I studied the piano, practicing, improvising, and composing music for long hours. So, I had expected to have a career as a musician, but my parents talked me out of it, saying that I didn't have the temperament to travel around and perform in public. And when the time came for me to decide, I realized that they were probably right and went to the University of Oxford instead, studying psychology and philosophy.

My time at Oxford was wonderful. This was the heyday of the branch of philosophy known as linguistic analysis, and I was fortunate to have wonderful tutors. I spent a particularly large amount of time studying the philosophy of mind. We would have long discussions about the relationship between illusion and reality and concluded that all perception is the creation of the mind, and so all perception is, in a sense, an illusion. Psychologist Richard Gregory, who's well known for his books on visual illusion and was a professor at Cambridge, often came to Oxford to give lectures about illusion and present illusions that he'd discovered.

Since my strongest interests were in both illusion and music, perhaps it was a foregone conclusion that I would end up creating musical illusions. Later on, I started approaching my illusions in a way that's very similar to musical improvisation: beginning with an idea, then playing with it, refining it, and distilling out its essence. There's an excitement in the creative process; I have this feeling of venturing into the unknown, which is

the most exciting part for me—even more rewarding than documenting the effects I discover formally.

I began experimenting at the University of California, San Diego in the late 1960s, when it had just become possible to create sounds using computers. At around that time, Max Matthews was doing pioneering work in computer music at Bell Labs, and Roger Shepard and Jean-Claude Risset were using computers to create their Shepard tones and the Risset Glissando. I approached it differently. I had access to a computer which controlled a function generator and first set about creating sequences of tones in order to study how well we remember the pitch of a tone in the context of other tones. Then I thought, instead of one tone, I could create two sequences of tones at the same time, which I played through headphones, with one sequence being sent to the left ear and one to the right ear. That was how I generated the "octave illusion," and from there I continued to the "phantom words" illusion.

MM: How did that come about exactly?

DD: I first took the words "high" and "low" and played them in sequence such that one ear received "high, low, high, low" while the other ear received "low, high, low, high." To find out what would happen, I recorded this sequence and played it through loudspeakers. To my surprise, I heard entirely different words and phrases coming from the speakers, such as "I know" and "long time" and "no pie." So, I tried using further words, looking up and down, turning around, and walking around the room, and I found that even more phantom words and phrases emerged. It also seemed that what I was hearing tended to reflect what was on my mind or what I'd been doing recently. It seemed that these illusionary words and phrases were reflecting thoughts in the back of my mind.

So I decided to choose some really good examples, and I went through dozens of words and phrases and found that only some of them would produce convincing phantoms. This was before the days of googling things on the web, so I bought a book called *How to Name Your Baby*, and it turned out that the names in it were a very good base for phantom words. Hilda, Boris, and

Igor are some great examples. I collected more information when I played the alternations to classes of students in a course I was teaching called Illusions in the Brain. The students at my university have very diverse backgrounds, and many of them speak English as a second language—I found that the students heard words in Mandarin, Cantonese, Korean, Japanese, German, French, Italian, and Russian, to name only some examples. Interestingly, when the students heard a phrase in a different language, they were sometimes convinced that I had inserted it into the sequence and that I was only pretending they were hearing an illusion. They often refused to believe me when I insisted that I hadn't inserted other words.

MM: What are your criteria for picking new words or phrases for your phantom words experiments?

DD: First of all, you need to have two alternating syllables. That seems to be ideal. Three syllables doesn't work that well. Another thing I found was that there was a temporal range in which the phantom words worked. For example, if the syllables were shorter than, say, 180 milliseconds in duration, it just sounded bad. If they were more than 250 milliseconds in duration, you didn't get phantom words. There is a rather narrow range in which it works. This range happens to correspond with the range of syllables in normal conversational speech. I tried a lot of other things. For example, at one point I thought that it would be necessary to have softer sounding consonants rather than harsh consonants. But that turned out not to be the case; I don't think it made any difference.

It's also important that the syllables presented to the two ears should be strictly simultaneous. It doesn't work if they are staggered in time. Another thing I noticed is that, for phantom words to appear, you really need to play the pattern for ten or twenty seconds. At first, you just hear a jumble of meaningless sounds that seem like nonsense, and then different words and phrases would appear quite suddenly. The more you listen, the more phantom words and phrases appear. In fact, if you play a bunch of them one after the other, say, one for two minutes and another for a further two minutes, then the more you listen, the more phantoms you hear.

Another thing I discovered was that it was very useful to prime people. For example, you could suddenly call out, "Oh, I'm hearing the word 'time'!," and you could be pretty sure that a lot of people would start hearing that word. Interestingly, in my class of undergraduates at the University of California San Diego, the female undergraduates tended to hear the word "love" pretty much regardless of the actual words I played. They just liked the word love—I could be sure that if I called it out, a very large number of people would then hear it. I have to say, that wasn't true of the male students; I suspect that they sometimes heard things which would not be fit for publication and didn't really talk about it...

At all events, what one hears seems to reflect very clearly what's on one's mind. For the "high/low" alternation, I would often hear the phrase "no pie, no pie" when I was on a diet and trying to lose weight, but when I went off my diet, I'd hear "pie, pie, pie"! If people are depressed, they sometimes hear depressing things. But it works very well for students in a class to just call things out. They would hear what each other heard, and they would write the words down and talk about it, which was a very happy experience for them. They loved it.

MM: The criteria for phantom words seem to be very technical or formal: There should be two syllables, they should have a certain length, and the shape of the words is crucial. What about the meaning? Seeing as you mentioned *How to Name Your Baby*, I guess it's not so much about the content of the raw material rather than what's on people's minds when they listen to it.

DD: Definitely. I remember a friend, a scientist, who was really hoping to get the Nobel Prize. And for one of the phantom words, I think it was the word "nowhere," he insisted that I had inserted "Nobel, Nobel, Nobel." There are many such examples. I sometimes listen to phantom words to try to find out what kind of mood I'm really in.

MM: Then you can test your own mindset by listening to the alternations and seeing what phantom words come up.

DD: I think so. They are similar to a Rorschach test—the psychological test where the subjects see an inkblot and are asked to describe what they see. They might see an angel or a monster, for example. It's the same concept. But I think that phantom words work better than the visual inkblot test, so much so that they should be used in a clinical setting.

MM: How can we picture your empirical studies in psychology with phantom words? What is the setup? How can we imagine the work?

DD: An example would be the setup for determining the effect of whether the words were coming from your left or your right ear, which was very precise. The listener would be in the middle of the room with one speaker to their left and one speaker to their right, all measured and placed very carefully. Then I would play the words, and the subjects would write down what they heard and where it was coming from. Afterwards, I would have them turn around and face the opposite direction, and I would play them the same words. That's how we found out that the right-handers would tend to hear words coming from their right, regardless of which direction they were facing. That is, it would seem that the illusory words were coming from one speaker when they were facing in one direction, and the other speaker when they were facing the other direction. This turned into a paper that we wrote up and published as a talk.[1]

Another experiment I'm setting up involves priming. As I was saying, people do tend to hear words that are suggested to them, and we're looking at two ways of looking into this. One is to call out a word and see if people write that word down more often than otherwise. The other is to have them in front of a computer screen and see whether they start to hear words that appear on the screen. There is a related effect, the "Laurel or Yanny effect," that was very popular a few years ago. It was discovered by a girl in high school who looked up the word in an on-

1 Diana Deutsch, Kevin Dooley, and Trevor Henthorn, "Phantom words are heard more frequently as coming from the right side of space," *Journal of the Acoustical Society of America*, vol. 146, no. 4 (2019).

line dictionary—I think it was the word "Laurel," and she heard "Yanny" instead. She asked other people, and some heard "Laurel" and others "Yanny," and then she posted this on the Internet, and it went viral. The thing here is that people were presented with two options, either "Laurel" or "Yanny" above the word "vote," so people really were primed to hear either one or the other. In my phantom words paradigm, I don't do that unless I deliberately suggest priming. People come across what they're going to hear freely. As a result, they hear many more phantom words, not just one couple.

MM: You published *Musical Illusions and Paradoxes* as a CD,[2] and you also published a CD with phantom words.[3] People can carry out their own experiments with these CDs, but they can also listen to them as music. I know that some DJs play them in their sets. There's definitely a strong connection between phantom words and music, and you could argue that they're musical compositions—so, in a way, you ended up working as a composer after all. What is your own view on this? Do you think of this aspect of your work as musical composition?

DD: I really do approach both the phantom words and the other illusions as a composer. As a child, I did a great deal of improvisation on the piano, and I was very serious about composing. I would walk around with music manuscript paper, in case I had an idea, and I would work on it. I still essentially do the same thing. With computer sounds, I start off with something, maybe by accident or maybe an inspiration, and I work on it in various ways. After playing with it for a long time, sometimes even months, I end up concluding that I have managed to distill the essence of what I was looking for. That, I believe, is very much like the process of composition: starting off with an idea which sort of comes as a surprise, and then realizing that it's something to work on, and so you just keep working on it. There have been other re-

2 Diana Deutsch, *Musical Illusions and Paradoxes*. Los Angeles, CA: Philomel, 1995.
3 Diana Deutsch, *Phantom Words and Other Curiosities*. Los Angeles, CA: Philomel, 2003.

lated things of course, for example Steve Reich who wrote the piece "Come Out" in 1966. It's a slightly different paradigm, but there's no doubt it's a musical composition. It's basically someone speaking, and his words are being repeated constantly. People do regard repeating words and phrases as compositions.

MM: Since you mention minimal music compositions, I'm curious if you were listening to that kind of music at the time, if you have been inspired by it, and what you think about minimal music.

DD: In terms of a discovery, I hadn't really known about this other work. Somebody pointed it out to me, and of course, I then recognized that there were similarities. I think minimal music in general is very interesting, because the brain keeps attempting to make sense out of what is being repeatedly presented. You hear all kinds of different things. It can cause you to go into a sort of meditative state, I suppose, and it can make you very relaxed as well.

MM: Would you consider the phantom words to be a kind of minimal music in a way? Between art and theory, where do you think your work sits?

DD: I think they are essentially minimal compositions. Even though I decided to study psychology and philosophy at the last minute, my heart has always really been in music, and my research has been a way of mixing them together.

In philosophy, the whole question of the relationship between illusion and reality was very interesting to me. We had many discussions at Oxford regarding other minds: I know that I have a mind, but how do I know that anybody else has a mind? Related to that, there's the empirical work in psychology showing that people really see different things, like different colors. There are a lot of differences between people in how they perceive colors. And in many of my illusions, I found that there are large differences between people in what is heard too. Right-handers and left-handers hearing different things in the octave illusion, for example. Evidently, this relates to differences in brain organization.

And there are also differences that depend on where you grew up and what language you were exposed to, particularly in childhood. I did one study where I compared people who had grown up in the South of England with people who grew up in California using an illusion I discovered called the "tritone paradox." And it turned out that, when people from the South of England heard it one way, people in California heard it the opposite way—and people from Vietnam heard this pattern quite differently from people who were born and raised in California. And it also happens that children and their mothers tend to hear the same thing as each other, at least for one of the illusions. Who the person is, then, does have a huge effect on what's heard.

And, of course, that leads to very difficult and interesting questions about music. When an orchestra performs a piece, which perception is the *real* music? Is it the music that was originally in the mind of the composer when they first imagined the piece, or in their mind after working on it for a long time, or in the mind of the conductor when they're listening to all the instruments simultaneously? Or is it in the mind of one of the performers, or is it in the mind of a member of the audience who knows the piece well or a different member of the audience that has never heard it before? Where is the real music? Big question! I don't know that there is an answer. One can only say that it depends on the mind of the individual listener. And so, one can look at it either way—music or not—with my compositions too.

MM: Finally, I was interested in the element of chance involved in finding the illusions. I know that there were some occasions when you went from working on one illusion to the discovery of the next, in a way by chance.

DD: Yes, one illusion that I discovered really by accident is the "sometimes behave so strangely effect." This is based on a repeating phrase of spoken words. When it is played four to eight times, depending on the individual listener, you start to hear it as sung rather than spoken. I discovered this effect while I was recording the opening commentary to my first CD, *Musical Illusions and Paradoxes*. I had recorded, "the sounds as they appear to you are not only different from those that are really present,

but they sometimes behave so strangely as to seem quite impossible." I didn't realize at the time that this would turn into music. I started playing with something else, and I had this piece just running constantly, and suddenly it seemed to me that a strange woman had entered the room and had began to sing! For a few seconds, I was alarmed. Then, I rather rapidly realized that I was hearing my own voice coming out of the loudspeaker. But now, instead of sounding like speech, it seemed as though I was singing. Of course, I recorded the phrase again and played it back to other people and did my experiments on it. But that was another big surprise, to experience once again how sound and our perception of it could behave so strangely.

Now, although I discovered several of my illusions by chance, in most of these cases, following the discovery I would work on the sounds, often for months, so as to be finally satisfied that I had created a passage that distilled out the essence of the illusion. This was true of the "phantom words" illusion, as we have discussed. As another example, having discovered the "octave illusion" by chance, I published it after working with different sound parameters, such as duration and pitch range, and convincing myself that the parameters I had originally used were the best ones. Other of my illusions were not accidental discoveries. I generated the "tritone paradox" after several months of working with patterns composed of similar tones, and I created the "tritone paradox" based on my conclusions from these experiences. I discovered the "mysterious melody" illusion based on a theory that I had earlier proposed. This theory predicted that when listening to a well-known melody with the notes placed randomly in different octaves while retaining their names (C, C#, D, etc.), one would be unable to identify the melody; the illusion was as predicted from the theory. I composed my "pitch circularity" illusion entirely from a theoretical assumption, and the process of fine-tuning this pattern took me several months. So taken together, my illusions were derived from chance discoveries, as well as from experience, theoretical assumptions, and long processes of fine-tuning.

Vera Molnar, *Déhanchement*, plotter drawing, ink on paper, 27 × 23 cm, 1990

POLICE AMBIENCE

this somewhere
that is still
 moving

this is where

"K" Line

boxcar

where the light points
something in the shadow
reveals more

a knock at the door, a man
on the inside opens it, all those
inside go out

to happen

no state, an edge,
foot bridge

AUTUMN AMBIENCE

AUTUMN RHYTHM

Still,

turn

and you see the point
of connection

youth, who wouldn't
to know

this air, this somewhere

"K" Line boxcar, something in the shadow

that is still moving

we'll choose it

a knock at the door, a man on the outside
opens it, all those outside
go in

still people appear
before
reference, awareness is there
in what's
away

POLICE RHYTHM

View from the Balcony

David Grubbs: For The Sound of Distance festival, I had proposed a trio performance, *Three Simultaneous Soloists*, with the idea that the three musicians would be situated as far away from one another as possible, each either playing acoustically or with the individual performer's means of amplification next to them, and with the thought that the musicians should be playing quietly enough that the sounds emerge from three distinct points in space. The sound perspective experienced by the audience should change significantly based on the location of the listener, and without explicit instructions, people would be encouraged to explore the space. To my huge relief, when I realized I wouldn't be able to travel to the festival, you jumped into the planned trio with Andrea Belfi on percussion and crys cole on electronics. So, first of all, I wanted to thank you for filling in for me at the last minute. How did you approach using the space?

Matana Roberts: I tried to approach the entire event from an energetic standpoint—deciding to tune my response to the energy of the space as I stepped into it. I was happy to do it, but Covid-19 meant I'd been avoiding most performance work and so it was also a really charged moment for me. I had some really big anxieties about playing saxophone in a space anywhere near people, a terror, because Covid supposedly infects the lungs and affects breathing. Things were getting postponed anyway, but I was being approached for things and was still like, "Uh... maybe next year." I just wanted to see how things went and to make sure I got vaccinated first. I just needed to consider all these different angles, because my experience of Covid had been pretty terrifying and I really needed a good reason to get back out there. The fact that you needed an emergency sub was a good enough reason for me: I thought, okay, this is a valid reason and the performance is spaced. Knowing the HKW building pretty well gave me a certain sense of security, although I was also aware there would be a crowd of people there. But in the end, I felt it would be a good opportunity to try returning to live performance; I think it was only my second after performing in Utrecht at Le Guess Who? festival.

DG: At the last live music event I attended before the pandemic, you were playing solo in New York City at a Foundation for Contemporary Arts event. That evening, I remember taking the subway and for the first time not touching stuff on the train. I'm normally something like the opposite of a germophobe; instead, on that journey, I remember taking the subway and keeping my hands in my pockets, trying my best to keep my balance and to not touch anything even though the car was really crowded. Events at the Foundation for Contemporary Arts are often held in honor of both older and younger artists, and I remember people like Meredith Monk being there. I was thinking, my god, I hope all of these older folk are going to be okay. That was the last event I went to for months, a year even.

MR: I remember, because I was heading back to Europe to finish my fellowship with the DAAD, the German Academic Exchange Service, and barely made it back. Borders were starting to close, things were becoming more restrictive, it was starting to become a little strange. I had all these plans about things I'd be doing to finish up my fellowship, only to return to a descension into some pretty severe isolation. Playing the HKW event was a really big deal for me as I hadn't had much of a chance to be around people. I was still terrified to even go to a show, which is something I'm still working through. I was really at a crossroads of trying to determine... well, a part of my life is live performance, and it's something I really value... but maybe I'm not going to get to do it anymore... and then I received your email. Okay, here's the moment, give it a try, I thought. Walking into the space with that kind of energy, stepping into the building with that kind of energy, and then seeing people—I felt it was very courageous of people to come out and see things. And the energy, people's hunger to experience a space together, was very palpable in the room. And then the courage of crys and Andrea— I really admire them both, so to get the chance to do something with them, it just seemed it could be really nice.

DG: Where were you in the space? To what extent would you say you were playing solo and to what degree playing in a trio?

MR: It was fantastic. Everyone really worked with me to allay my nerves, but everyone was nervous, I think. They put me on the balcony, which was a really nice place to be for me. You know how they say that cats feel more secure high up looking down?

DG: Actually, I've never heard that!

MR: Oh yeah, cats love that. You can build cat superhighways in your home. That's the kind of feeling I had. I thought, Ah, now I get it! I felt secure up there. I had a lot of space and felt no one could crowd me up there in any way. I also had good sightlines between the other two musicians. I could hear the natural reverberation in the space, even with so the many bodies filling it. And because it wasn't a traditional seated-type concert setting, people were spaced out enough where I felt like it created a really nice reflective sound buffer of bodies. But still, it was nerve-wracking.

DG: Were people circulating through the event? How did the audience respond?

MR: Many people walked up near to where I was on the balcony to look up. Some people came up the stairs and sat at a distance away from me so that I still had ample space to move around. I like to walk around a bit, and that space was perfect for doing that. It seemed like some people knew exactly what was going on and others had no idea, so it was a mix of motionlessness and movement. Us performers were a little concerned about the time—we didn't want to run over the slot we'd been allotted—but we were also trying not to be super self-conscious about that.

DG: When Jan St. Werner and I had talked about the festival before Covid started, and in our talks about other possible events, we'd focused entirely on the aspect of distance. Apart from the charged nature of it being a return to performance for you, what experience as a musician did you draw upon with regard to distance? Have you ever played in a situation where you are a long way away from other performers?

MR: Things I've been asked to do in the past where I engage with certain art pieces, for example, come to mind. Here, the pieces are part of the ensemble; I can move back and forth within the architecture of the space. Once I gave a concert while they were still pulling the Whitney Museum together; I played at another event where everyone had to wear a hardhat as we snaked through the entire building from top to bottom. The HKW performance made me think a lot about how the reverberation of space becomes personified. For some years I was busking on the streets and in the subway, and it made me think about that too. But in terms of a band situation, I don't think I've ever experienced being so distanced, so far apart—unless it's a gig where the sound system has to be a certain distance away and where the musicians have to be spread out in some way. That sort of situation always creates a drama, because not everybody can hear everyone, and everyone's monitors are spaced in a particular way to try to make it work, but it doesn't work. So, I appreciated that my past experience of distance wasn't really so much what was needed for the HKW performance—it really was about the primacy of the ear.

> **DG:** At the event you played for the Foundation for Contemporary Arts in March 2020, you entered from the back of the room. That experience of where is the sound coming from?, it was great, it changes the atmosphere immediately.

MR: That's one of my favorite things about the saxophone, especially the alto. I'm biased, but the alto can grab sound and space more than some of the other saxophones, in a way that it really reverberates in the human body. I can feel it while playing, so it's interesting to hear it.

> **DG:** The idea for *Three Simultaneous Soloists* came from two experiences I'd had. One was playing in a trio with Steve Roden and David Watson in a concrete parking structure in Los Angeles where we were spread out some distance apart. That wound up feeling weirdly alienating—a learning experience, something I was glad to have done, but which I can't really describe as fun, more that it was isolating. On the one hand, it was excellent to

see this small crowd of thirty to forty people moving collectively as a group. They'd come toward you while you were playing, hang out for ten minutes or so, and then somehow in an unspoken group-dynamic they'd head off to find the next performer. That sad moment of watching the audience walk away was like a bittersweet dream: "Come back...!" The other time I did something like this was with *Four Simultaneous Soloists*, a series at Pioneer Works in Brooklyn during the Anthony McCall exhibition there. Four of Anthony's vertical solid-light works were displayed in an enormous hall, and for each of the four concerts four performers were situated about 100 feet apart, each playing quietly either acoustically or with amplification placed next to them, so that there were four distinct points in space for the sound, and the audience had to move through the space to bring each of the "solo" performances into focus acoustically. There's such a natural hush to Anthony's work that it already invites people to be attuned to the threshold of perception. My concern with the HKW performance was that there wouldn't be a similar visual transformation of the space, and I wondered if the great experience I'd had playing among Anthony's solid-light pieces would carry over there.

MR: That's interesting. A certain sort of transportation happened for me at HKW in terms of having to deal with some of the restrictions of the space. I know you'll have experienced this visiting different countries—I'm thinking about the UK, for instance, and standing between someone who's from "up north" versus someone who's from "down south" and listening, trying to make sense of the different tones, so that you can really focus on what's being said. There's something we all have to do to tweak our ears to make sure we hear what's going on, but there's also a division happening at the same time. In those terms, I felt I had one ear on Andrea and one ear on crys and then there was a splice, some connection between my two ears. For myself, I was just hoping it'll work out. The only other thing I can compare it to is when I was a high school drum major, and led marching bands.

DG: I was going to ask you about marching bands. I can picture you playing saxophone in one.

MR: I *led* the marching band! It was a 125-piece band, huge! Ear relocation was really important in terms of signaling, and so was listening—you had to keep your eyes and ears divided to make sure that things were coming together. So, in terms of distance, that's one of the few things I can draw on. Or years ago, Anthony Braxton hired about fifty of us musicians to play in a hockey rink in Connecticut. Everyone was miked up and had one of his pieces to play, and we were supposed to navigate this huge hockey rink but not in any particular direction, just by crossing sounds. Which makes me think a lot about Charles Ives and his interest in that sort of sound location in terms of dealing with marching bands.

DG: It's a Connecticut thing.

MR: Yeah, it's a Connecticut thing. I feel that, as an improviser—or anyone who plays in any sort of band—there's this division that has to happen to achieve any sort of cohesiveness—a division of hearing and focus. And the restriction at this HKW event was the fact that I could sort of see crys and Andrea, but I couldn't fully see them. I could see enough to know what was happening, but really, in order to fully understand what was happening, it was more about listening. Playing in the subway or in the streets, you're playing but also listening for potential danger. Just to be sure that everything's cool. I'd always set myself up with my back to a wall or some other surface so that no one could come up behind me, but you have to pay attention.

DG: I was reluctant to ask about privileging the ear over the eye—I experience that I look and listen but rarely do I do either in isolation. But it does sound as if distance in this case made it more profoundly a listening experience, or at least tilted it in that direction.

MR: I know that when I'm playing with people I'm comfortable with or have a little history with—I didn't have with either of crys and Andrea—at least a musician I've played with before and have some familiarity with, and I'm not playing music on a page—

DG: What, you didn't get the score? I faxed it to you.

MR: You almost gave me a heart attack! Uh, no...—anyway, there's a kind of relaxation that can happen so that you really focus on what's going on in the moment versus playing a score or leading a band. I've had experiences where I'm playing the score but I'm also leading the band, and that takes an extra—a third eye and third ear—to make sure you hear what's going on while you're also focusing on what you're doing in the moment. Sometimes it's so terrifying. This wasn't terrifying, but there was the energy of playing saxophone in a space among the people there. Yes... it was still terrifying! I just remember feeling really good about doing it, before I hightailed it out of there.

The Body as Sound, the Sound as Body

"Composition ties music to gesture, whose natural support
it is; it plugs music in to the noises of life and the body,
whose movement it fuels."—Jacques Attali, *Noise*[1]

The distance of sound is a notion that has fascinated me for a long time.
It is also the reverse of the title of a festival that took place at the Haus
der Kulturen der Welt (HKW) in Berlin in October 2021, The Sound of
Distance, which prompted me to consider this particular fascination
more closely. My interest has to do with my perception of sound as
both a listener and a performer. It pertains to my physical and mental
affectedness and, ultimately, to the possibility of sound navigating
the relative closeness to self. In an attempt at entangling some of the
interdependencies at play, what follows here are personal accounts of
some of these manifestations from the perspective of the listening
body: the body as sound, and the sound as body. As Salomé Voegelin
writes, "Sound only knows the intertwining: a primary closeness. It is
then not a matter of the bridge, crossing the subject–subject or subject–
object divide, but of experiencing a world of primary simultaneity
without separation. This does not mean not to see and hear discrimi-
nation."[2] You may not consider my accounts empirical truths, for what
I hear and feel from a certain sound may differ from your own reac-
tions; added to that is the relative limitation of words in conveying the
complexity of sound, for, as composer Justin Christensen has expressed,
words may simply be "hyper-rich depictions of reality that stand for
some other realities."[3]

Coincidentally, I am contemplating the kind of music that might
best accompany the writing of this text partly due to the relentless
Techno punctuations coming from my neighbor's apartment. I con-
sider whether I might find ease in some Bach piano partitas or some
stripped-down drone compositions by Éliane Radigue. I choose some-
thing more charged instead, something familiar: the singer-songwriter

1 Jacques Attali, *Noise: The Political Economy of Music*. Minnesota, MN:
 The University of Minnesota Press, 1985, p. 142.
2 Salomé Voegelin, *Sonic Possible Worlds: Hearing the Continuum of Sound*.
 London: Bloomsbury Academic, 2014, p. 111.
3 Justin Christensen, *Sound and the Aesthetics of Play: A Musical Ontology
 of Constructed Emotions*. Cham: Palgrave MacMillan, 2017, p. 94.

Sam Amidon. At once, I am pulled into his world of sound. I know it quite well, and so it has become my world as well. By this, I don't mean that I know the technical or ephemeral details about the recording. I also don't think a note-by-note transcription of the music or playing along to the record would justify such an assuming statement. Rather, through my repeated listening, I feel, the music has afforded me closeness, and I have come to embody it as a result.

I now react to it in such a way that my body predicts it. This prediction comes before conscious cognition and has helped create a corporeal memory of the sounds. How did I come to embody it so naturally? Am I reacting to the sound, or am I enacting it to a certain degree? Do my bodily responses and gesticulations bring forth my inner feelings, or are the various sonic parameters at play shaping how I feel? Indeed, it is hard to tell where my (sonic) body starts and where it ends, where the line is between the interior and the exterior. This entanglement is endlessly fascinating, but more to the point, it facilitates movement in both directions, inward and outward. I find myself humming below Amidon's voice, nodding my head to the beat, slightly jagging myself sideways every so often. I begin to write. I am moved to. I am listening to Amidon and to my thoughts.

What do I mean by "closeness to the self"? Perhaps I am thinking of a kind of homeostasis, a balance of the interior and the exterior registers of consciousness or, in more scientific terms, a state in which cognitive and motivational brain mechanisms reinforce each other. How does sound figure into this closeness, this distance, to oneself, to the other? It is interesting to consider sound's mutually psychological and physiological effects, a kind of embodiment perhaps. Even though the Amidon track has long come to an end, I hear a faint ticking internally along with my thoughts, not unlike that of a steady metronome beat. This pulse reflects the tempo of the song and, with it, a kind of continuous forward motion. It seems I've picked it up as a kind of pacemaker to guide my stream of consciousness. Fundamentally, this closeness has to do with the self's ability to sustain its rhythm by way of entrainment. Here, I go by the dictionary's definition of entrain, that is "to draw along with or after oneself," in this case, meaning the self's ability to internalize the external sound and carry thoughts and observations along with its rhythm. For certain, I became synchronized to the song's beat at some point during my listening. This ability to precisely synchronize my body's movement with an external rhythm

forms the core of entrainment mechanisms: the ability to sponta-
neously adjust my internal feeling based on prediction.

I think about how the click in my head arrived there, how it be-
came a subconscious automatism. In order to understand this passing,
from one body (the producer of sound) to another (my own receiving
body), it is important to untangle the basic interactive concept of em-
bodied music cognition as laid out by Marc Leman. Here, interaction
is concerned with cyclical actions in relation to the environment that
can be semi-automatically controlled by means of sensorimotor pre-
dictive models in the brain, requiring limited cognitive resources,
which in turn enables other activity alongside or as a result of it.[4] For
instance, the foot tapping of an instrumentalist who uses it as a cue for
timing, thereby structuring more free expression that may be played
against it simultaneously. Emulation, as opposed to interaction, fo-
cuses more on continuous aspects of movement and is understood as
human rhythms temporally and spatially aligning themselves with
musical expressions on a larger scale, again using beat synchroniza-
tion as a timer. Think of the deliberately fluctuating pacing in your
dance patterns in reaction to a song's verse, as opposed to its chorus.

Motivation is another crucial component of Marc Leman's un-
derstanding of embodied music cognition. Being locked to the beat of
music may generate rewarding outcomes affecting cognitive activity.
In a 2017 book chapter, Leman and his co-authors noted: "As music is
a human construct of human action, the idea that music affords syn-
chronization should not come as a surprise. [...]. Ultimately, this
means that musical structure is made in such a way that it unleashes
the human disposition for synchronizing and being locked to the
beat." And they went on to say, "The most important effect, probably,
is that, due to synchronized movements along with music stimuli,
music becomes more predictive, apparently controllable and there-
fore more engaging."[5] Most people, including the so-called non-mu-
sical person, can relate to music because of its rootedness in human-
ness to some extent, and they will entrain themselves to it one way or

4 Marc Leman, *The Expressive Moment: How Interaction (with Music)
 Shapes Human Empowerment.* Cambridge, MA; MIT Press, 2016.
5 Marc Leman, Jeska Buhmann, and Edith van Dyck, "The empowering
 effects of being locked into the beat of the music," in Clemens Wöllner
 (ed.), *Body, Sound and Space in Music and Beyond: Multimodal
 Explorations.* New York: Routledge, 2017, p. 15.

another. With music then, we have invented an infinitely reciprocal form of, more or less, freedom of expression, one that is gratifying for its relative predictability and that allows for an array of affections—dependent, to some degree, on our bodies' readiness to be moved, our openness to be close.

How to nurture, then, this kind of movement? If we primarily entrain to rhythmical structures found in music, how might more open-form sonic formations affect us? And what about non-musical sound and the periodicity found in nature's rhythmical cycles? I scan my surroundings to contemplate this question. I hear: the periodical buzz my fridge emits, the unremitting stutter of the tram passing my street, the wind's recurring rustle in the trees, the intervallic bird call. The quieter I become on the inside, the more I notice the reciprocity at play: how I am formed by a constant shift between reaction and the enaction enabled by these sounds, their bodies. They serve as motor, as motivator, as animator, as conspirator, as accelerator. As perpetuator. For the possibility music offers, is to be in affect with another body—that of sound itself and that of its maker.

So we cannot dismiss the fact that being in sound means being formed by somebody else's making, and yet, the music we more often subscribe to has a certain materiality, something repeatable and commodified. This might be said of many art forms, and yet, with music at our immediate and affordable disposal, its innate power of manipulation on the subconscious may yield mechanisms of deceptive submission that are especially slippery. What I'm implying is at risk here, is the more vulnerable and active sense of self, that which opens up to the possibility of transformation by taking pleasure in one's body, "Through work, not through objects," in order to "play for the other, [...] to hear the noises of others in exchange for one's own, to create, in common, the code within which communication will take place."[6] Perhaps then, in order to relate to each other and to the world more attentively and to exercise our musical experience more consciously, we could emphasize "live music" and cultivate an understanding of sound that includes all sound, even nonhuman. At its root, sound is vibration, and so this should not only pertain to what we hear, what we call music, but also to more subtle exclamations of sound across the entire spatiotemporal spectrum.

6 Attali, *Noise*, p. 143.

If sound triggers the preconscious in us, where does it go to from there? Is it truly possible for me to conceive of your affectedness through mine? Rita Felski notes, "rupture vanishes without trace if it is not registered and acknowledged, that is to say, made the object of new attachments, connections, and translations between actors. Artworks must be sociable for them to survive, whatever their attitude to 'society.'"[7] Relatedly, Lawrence Kramer argues: "in a sense, without speaking of music there *is* no music, and we are free to speak of music by seeking to share its detours because music has always already begun that process for us."[8]

If a detour means leaving the main road to arrive at the destination from another perspective, perhaps we can rely on sound itself to guide us, trusting that our body will follow its path and extend itself into some becoming. In other words, we already are sound ourselves. This detour leads me to remembering my initial experience with Alvin Lucier's music. During a symposium dedicated to his work in Zurich in 2016, I experienced two full days of his compositions, some solely electronic, some mostly instrumental. In any case, the sound created was always visceral. Firstly, it drew me firmly into my listening sense. After some entrainment, I could not only follow the sounds' variable shapes and movements through space but soon felt it as another body—so vividly, so naturally, that I was certain it was just an extension of my own body, my own self. What was remarkable was the relatively low volume the pieces were played at, which at first seemed in odd juxtaposition to the vastness of the large concert hall. The state of otherness was unfamiliar to me then, undescribed. But I soon learned a formative lesson: sound, no matter how distant, is always an extension of a body; it is autonomous and yet tied to its source. It is a body of its own but contains part of another. This kind of intimacy with sound became somewhat addictive to me for some time. It would only happen live, inside a room, with the focused energy of other listeners around me; everyone committed to listening to the incalculable interplay of sound and space. Here, "to listen" is a weak representation of the physical and emotional response I was seeking.

7 Rita Felski, "Context Stinks!," *New Literary History*, vol. 42, no. 4 (2011), pp. 573–91, here p. 584.
8 Quoted from Lawrence Kramer, *Interpreting Music* (Berkeley, CA: University of California Press, 2011), in: Christensen, *Sound and the Aesthetics of Play*, p. 94.

Something more intimate was at play, something that philosopher Jean-Luc Nancy taps into when he writes: "Nakedness [...] to which nothing can acquiesce but the very ceaseless movement of the act of undressing oneself and the other standing in front of us."[9]

In an attempt to further illuminate my affectedness and the closeness I felt, I think of R. Murray Schafer, who considers hearing as a way of touching at a distance. He describes the crossover of the two senses, where the lower frequencies of audible sound meet tactile vibrations (at about 20 hertz). I imagine the vibrations above this threshold as some sort of removed sense of touch. To practice our sense of listening more deliberately seems logical in a pursuit of co-existence then, as a way of relating to our distances from others. Relating this touching at a distance to acts of communal listening, Schafer describes the first sense's infusion with a certain sociability and goes on to quote the reaction to this phenomenon by an ethnomusicologist who found links in the ethnic groups he studies: those with an "incredible sense of rhythm," always also share an intimate sense of physical closeness; "These two factors seem to co-exist."[10] Perhaps it is telling then that I set out here to describe the *distance* of sound from my perspective, my Western, white-conditioned sense of perception. I wonder if it would be possible for me to feel this closeness to the extent that the ethnomusicologist describes, this sense of rhythm that simultaneously comes from and brings forth closeness to others; a way of relating to each other and the world with the ear.

I direct my attention to the music coming from my speakers—its flow and the contour of the individual instruments that add to a shimmering whole. In turn, they direct my attention toward my body. There must be some valence of my own body as a perceptive vessel from which to relate to and understand others. Nancy, again: "'Body' firstly indicates the differentiation from the other: the border at which an existence begins and ends, that is to say, what lies beyond non-existence." And further: "Beings that do not [...] dispose of a fragile

9 Jean-Luc Nancy, *Körper*, ed. Peter Engelmann. Vienna: Passagen Verlag, 2019, pp. 14–15: "Nacktheit [...] der sich nichts schicken kann als genau die endlose Bewegung, sich selbst sowie den anderen, der uns gegenüberstehet, zu entkleiden." All English translations from this volume are by the author.
10 R. Murray Schafer, *The Soundscape: Our Sonic Environment and the Tuning of the World*. Rochester, VT: Alfred Knopf, 1977, p. 11.

palpable

really

exterior [...] essentially, would not exist."[11] The act of listening, then, forms a permeable membrane that opens toward the inside whilst being directed outward, and vice versa. Let's consider this opening more closely. Unlike our visual input, we cannot shut off sound or the aural sense that processes it; we are always already receiving, and thus always already part of another body. Like Nancy, we could also think of this body of sound as being unable to exist without another body of sound. Listening acknowledges this interdependence of bodies, their continuum. Or, more simply put, if we can give attention to a sound, we can give attention to a body, both that of our own and those of others. Perhaps this is indeed a way of productive coexistence. "Listening does not consider the thing but does the thing."[12] And, as Nancy continues: "So a body does not exist without other bodies. It does not mask one, and no one masks it—at least not without there being at play an unconcealment, an uncovering, a revealing of every body."[13]

The faint, high-pitched hum of the ventilation system outside my building enters me, forms me, but it also ascribes a body to what I cannot see. Directing my listening towards it, I create awareness for something, some body outside of me, but also some place inside me. I create an image through sound, an extension inward and outward that connects rather than separates. This is crucial to me in regard to coexistence; too often we are blind to what lies outside of us, consciously or unconsciously, and we have come to give our sense of vision, in its limited capacity, primacy to gather information. This is especially true for Western cultures. Of course, the ears also assist the eye and the other way around—hear the strike of a sledgehammer on a glass screen. Similarly, I have also always been fascinated by the sight of people adjusting the volume when listening to music, finding just the right balance for the situation, their momentary needs. It is as

11 Nancy, *Körper*, pp. 14–15. "'Körper' bezeichnet zunächst die Unterscheidung vom Anderen: die Kontour, an der eine Existenz beginnt und endet, das heißt das, was außerhalb (ex) des Nichtseins kommt." [And further:] "Existenzen, die nicht über ein Außen oder über [...] ein [...] labiles Außen verfügen [...] im Grunde würden sie nicht existieren."

12 Voegelin, *Sonic Possible Worlds*, pp. 110–11.

13 Nancy, *Körper*, pp. 14–15. "Es gibt also niemals einen Körper ohne andere Körper. [...] Er deckt keinen ab und keiner bedeckt ihn—zumindest nie, ohne dass dabei eine Entdeckung im Spiel wäre, ein Aufdecken, ein Bloßlegen jedes Körpers."

if they were navigating their readiness to be one with the sound. Indeed, this union might take on disparate intensities. I think of the phrases used to describe some of these longings too: "wall of sound," "in your face," "masking sound."

As a way of giving the listener the ability to hear more, German composer Jakob Ullmann writes music on the threshold of audibility. I remember a concert of his that was staged outside of the concert hall while the audience remained inside of it. I strained all through the beginning to hear where the music was going, until eventually I settled into the parallel sounds, and paradoxically, I felt no distance. Instead, I felt close to the music and to myself, and to the person sitting next to me, as well as to those many rows away. I attribute that to my listening presence at the time, and find affirmation again in Voegelin's words: "Listening generates what we are together not in contrast to each other. [...]. It looks at the contingency of belonging, not at its provenance or future place."[14]

What is loudness then, what is volume, and where is listening as an act of coexistence situated within it? Research in psychoacoustics has found evidence that listeners perceive an increase in volume as greater than an equivalent decrease.[15] This may well have to do with primitive survival strategies that come from encounters with approaching versus receding objects. I ponder how this plays out in a concert hall setting and quickly recall the piece by David Grubbs, *Three Simultaneous Soloists*, performed as part of The Sound of Distance festival at the HKW. Three separate performance areas were setup throughout the HKW's large entrance hall, with the players spaced out in such a way that one felt urged to navigate the distance between them, choosing between a close-up of one or a relative blur of all three. After some time spent crossing between these two perspectives, I became slightly frustrated at how the distance severely restricted the players' capacity for interaction between each other and hindered the development of a reciprocal narrative and collective tension. This tension, I noticed, was to be made by the audience itself. I started moving through the space, creating all kinds of routes, some slow, some fast. My body movement, my pace, became an instrument

14 Voegelin, *Sonic Possible Worlds*, pp. 110–11.
15 For example, see Lawrence D. Rosenblum, "Perceiving Articulatory Events: Lessons for an Ecological Psychoacoustics," in John G. Neuhoff (ed.), *Ecological Psychoacoustics*. Amsterdam: Elsevier Academic Press, 2004.

with which to traverse the many synchronous distances in the room, among the people.

In writing this, I just surprised myself by momentarily conflating the end of the Grubbs performance with the concert on the following night, staged in the same room: Annea Lockwood's *bayou-borne, for Pauline Oliveros* (2016). For this piece, the players themselves moved through the space and the gathered audience, following instructions in the score that describe the course of the bayous along the Hudson River. I attribute my confusion to sound's perpetual nature and its power to inscribe a constant state of becoming that extends beyond the boundaries of my own body, the specific rooms of the HKW, and the composition itself. For the *Three Simultaneous Soloists* performance, I let my body be the sound; for Lockwood's piece, the sound was the body. In both cases, the sound was distance too: between me, the players, the other audience members, and between imagined worlds (river flows) and actual physical bodies in space. I gather that sound and distance are synonymous, and, paradoxically, with attention to sound through listening, there is no distance, just one place, one shared body. From this perspective—no matter how vulnerable, how resistant—sound affirms our inherent potential for togetherness.

I come back to my room, to the sounds around me. It takes me a while to register them, to let go of my thoughts, to be present. I close my eyes. My listening ushers in a sense of place, of belonging. It leaves me with an impression of the word "sound" as being whole, healthy, and grounded.

Thanks to Laura Preston

Vera Molnar, *Hypertransformation*, plotter drawing, ink on paper, 20 × 20 cm, 1976

+ Detlef Diederichsen has been head of the Department of Music and Performing Arts at the Haus der Kulturen der Welt in Berlin since 2006, where he has initiated several series and festivals, including "Wassermusik," "On Music," and "Worldtronics," as well as theme days, such as "Unmenschliche Musik" (Unhuman Music), "Doofe Musik" (Stupid Music), "No! Music," and "100 Jahre Copyright" (100 Years of Copyright). He previously worked as a musician, music producer, critic, journalist, editor, and translator. He has released several records with his band Die Zimmermänner since the 1980s, most recently the album *Ein Hund namens Arbeit* (2014).

+ Arno Raffeiner is a cultural journalist and works in the Department of Music and Performing Arts at the Haus der Kulturen der Welt. He was editor-in-chief of *Spex* magazine and editor at *Groove* magazine and the literature portal *readme.cc*. He has written on pop music, film, and digitization in *Der Spiegel* and *Zeit Online*, among other publications, as well as in the anthologies *Electronic Beats* (2021), *Experience: Culture, Cognition, and the Common Sense* (2016), and *Die Sichtbarkeit des Lesens. Variationen eines Dispositivs* (2011).

+ Jan St. Werner is an artist and composer. As co-founder of the band Mouse on Mars, he stands for undogmatic electronic music that combines experimentation and concept. He has released more than a dozen solo albums and runs the mixed media platform Fiepblatter Catalogue. Werner has exhibited his sound interventions and installations at the ICA in London, the Kunsthalle in Düsseldorf, and the Lenbachhaus in Munich, among others, as well as at the Ural Biennale and documenta 14. He was artistic director of the Studio for Electro Instrumental Music in Amsterdam and has taught in various institutions, including the fine arts academies in Nuremberg and Munich and at the Massachusetts Institute of Technology (MIT) in Boston.

+ J.-P. Caron is a philosopher and artist who teaches at the Universidade Federal in Rio de Janeiro. He has been involved with noise and experimental music for more than fifteen years and is co-founder of the label Seminal Records, through which he has released several albums himself. His doctoral thesis deals with the aesthetic philosophy of John Cage in the context of contemporary art ontology and the philosophy of language.

+ Diana Deutsch researches the perception of sound and language. She is Professor of Psychology at the University of California, San Diego and Adjunct Professor of Music at Stanford University. Deutsch is known for her discovery of various musical and speech illusions, including the octave, scale, glissando, phantom words, and speech-to-song illusions. Among over 200 publications, her *Musical Illusions and Phantom Words: How Music and Speech Unlock Mysteries of the Brain* was published in 2019.

+ David Grubbs is Professor of Music at Brooklyn College and The Graduate Center, City University of New York, as well as author of *Good Night the Pleasure Was Ours* (2022), *The Voice in the Headphones* (2020), and *Records Ruin the Landscape: John Cage, the Sixties, and Sound Recording* (2014). He has also collaborated on the artists' books *Simultaneous Soloists* (with Anthony McCall, 2019) and *Projectile* (with Reto Geiser and John Sparagana, 2021). As a musician, Grubbs has released fourteen solo albums and appeared on more than 200 releases.

+ Tim Johnson is a poet and editor, based in Marfa, Texas, where he owns and operates the Marfa Book Company with his partner, Caitlin Murray. He edited the book *Al río / To the River* (2022) with Zoe Leonard and has contributed essays, poems, and translations to several anthologies, magazines, and journals, including *Pathetic Literature*, *The Against Nature Journal*, *Eights*, *Adventures*, and *The Paris Review*.

+ Marc Matter is as a composer, artist, author, and researcher. His work is concerned with the musicality of language, acoustic poetry, experimental storytelling, as well as media technologies and everyday sounds. He is co-founder of the groups Institut für Feinmotorik and The Durian Brothers, as well as the diskant label. Since 2011, he has been a lecturer in music and text at the Institut für Musik und Medien at the Robert Schumann Hochschule (RSH) in Düsseldorf and, since 2021, a research associate in literary studies at the University of Hamburg.

+ Vera Molnar is a pioneer of algorithmic art, who, in developing her own form of geometric abstraction, has drawn from constructivism and conceptual art, cubism, and other avantgarde movements. She started developing combinatorial images in 1959 and began working with computers in 1968, using the programming languages Fortran and Basic to generate plotter drawings. She is co-founder of the artistic research groups GRAV and Art et Informatique.

+ Gascia Ouzounian is Associate Professor of Music at the University of Oxford, where she directs the European Research Council-funded project "Sonorous Cities: Towards a Sonic Urbanism" (soncities.org). Her work is concerned with the philosophies, technologies, and aesthetic ideologies that shape ideas of sound and space, within and across such fields as music, sound art, psychology, engineering, and urban design. She is the author of *Stereophonica: Sound and Space in Science, Technology, and the Arts* (2021) and numerous articles on sound art, experimental music, and sonic urbanism.

+ Patricia Reed is an artist, writer, and designer. Her work addresses social transformations of coexistence at planetary dimensions, focusing on the interactions between world-models and practices of inhabitation. Recent essays appeared in *The Unmanned* (2022) and the anthology *Geognostics* (forthcoming). Reed is a co-author of the *Xenofeminist Manifesto* (2015), written by the Laboria Cuboniks group, and a compilation of her writings will be published by Holobionte Ediciones in 2023.

+ Matana Roberts is a composer, band leader, saxophonist, sound experimentalist, and mixed-media practitioner. Best known for the acclaimed *Coin Coin* project, which aimed to expose the mystical roots and channel the traditions of American creative expression, Roberts has dealt intensively with narrative, historical, social, and political forms of expression within impro-visatory musical structures. In 2019, Roberts was a fellow in the DAAD Artists-in-Berlin Program.

+ Paolo Thorsen-Nagel is a German-American musician and artist. In his sound, performance, and moving image works, he concentrates on the relationship of sound to physical and psy-chological space and the possibility of making these features palpable in a given listening context. He was Sound and Music Advisor for documenta 14, as well as the curator of *Listening Space*, Athens, and co-curator of the documenta 14 concert series at Megaron, the Athens Concert Hall (2017).

Colophon

Das Neue Alphabet (The New Alphabet) is a publication series
by HKW (Haus der Kulturen der Welt).

The series is part of the HKW project *Das Neue Alphabet*
(2019–2022), supported by the Federal Government
Commissioner for Culture and the Media due to a ruling
of the German Bundestag.

Series Editors: Detlef Diederichsen, Anselm Franke,
 Katrin Klingan, Daniel Neugebauer, Bernd Scherer
Project Management: Philipp Albers
Managing Editor: Martin Hager
Copy-Editing: Mandi Gomez, Hannah Sarid de Mowbray
Design Concept: Olaf Nicolai with Malin Gewinner,
 Hannes Drißner

Vol. 21: *Sound – Space – Sense*
Editors: Detlef Diederichsen, Arno Raffeiner, and Jan St. Werner
Coordination: Arno Raffeiner
Contributors: J.-P. Caron, Diana Deutsch, David Grubbs, Tim
 Johnson, Marc Matter, Vera Molnar, Gascia Ouzounian,
 Patricia Reed, Matana Roberts, Paolo Thorsen-Nagel
Translations: Kevin Kennedy
Transcription (conversation Diana Deutsch and Marc Matter):
 Marisa Laugsch
Graphic Design: Malin Gewinner, Hannes Drißner,
 Markus Dreßen, Lyosha Kritsouk
DNA-Lettering (Cover): Erlend Peder Kvam
Type-Setting: Lyosha Kritsouk
Fonts: FK Raster (Florian Karsten), Suisse BP Int'l (Ian Party)
 Lyon Text (Kai Bernau)
Image Editing: ScanColor Reprostudio GmbH, Leipzig
Printing and Binding: Gutenberg Beuys Feindruckerei GmbH,
 Langenhagen

Image Credits:
Art works pp. 11, 12, 22–23, 36–37, 47, 50–51, 68 courtesy Vera Molnar and DAM, Berlin.
Video stills pp. 24–35 courtesy J.-P. Caron and Patricia Reed.

Published by:
Spector Books
Harkortstr. 10
01407 Leipzig
www.spectorbooks.com

Distribution:
Germany, Austria: GVA Gemeinsame Verlagsauslieferung
 Göttingen GmbH & Co. KG, www.gva-verlage.de
Switzerland: AVA Verlagsauslieferung AG, www.ava.ch
France, Belgium: Interart Paris, www.interart.fr
UK: Central Books Ltd, www.centralbooks.com
USA, Canada, Central and South America, Africa:
 ARTBOOK | D.A.P. www.artbook.com
Japan: twelvebooks, www.twelve-books.com
South Korea: The Book Society, www.thebooksociety.org
Australia, New Zealand: Perimeter Distribution,
 www.perimeterdistribution.com

Haus der Kulturen der Welt
John-Foster-Dulles-Allee 10
D-10557 Berlin
www.hkw.de

Haus der Kulturen der Welt

Haus der Kulturen der Welt is a business division of Kultur-
veranstaltungen des Bundes in Berlin GmbH (KBB).

Director: Bernd Scherer
Managing Director: Charlotte Sieben
Chairwoman of the Supervisory Board: Claudia Roth MdB
Federal Government Commissioner for Culture and the Media

Haus der Kulturen der Welt is supported by

 Minister of State for Culture and the Media

 NEU START KULTUR

 Federal Foreign Office

First Edition
Printed in Germany
ISBN: 978-3-95905-658-8

Vol. 3:	*Counter_Readings of the Body*
Editor:	Daniel Neugebauer
Text:	Olympia Bukkakis, María do Mar Castro Varela, Rain Demetri, Sabine Mohamed, Bonaventure Soh Bejeng Ndikung, Olave Nduwanje, Jules Sturm, Julius Thissen
ISBN:	978-3-95905-459-1

When the human gaze falls on a body, it constructs and deconstructs it. The setting for this is our daily life in all its different shapes and forms. The human body functions here as a semiotic system, an archive, a fiction, a projection screen, or an alphabet. The gaze that encounters it may manifest as an antagonist—be it incisive or flawed—yet it can itself disappear from view. The texts and images brought together in this volume seek to remove the body from the firing line and away from these judging and derogatory glances. They act as mirrors redirecting looks, points of view, and ideas to enable us to understand implicit and explicit processes of reading.

Vol. 4:	*Echo*
Editors:	Nick Houde, Katrin Klingan, Johanna Schindler
Text:	Lisa Baraitser, Louis Chude-Sokei, Maya Indira Ganesh, Wesley Goatley, Xavier Le Roy, Luciana Parisi, Sascha Pohflepp, Sophia Roosth, Gary Thomlinson
ISBN:	978–3–95905–457–7

"If sound is birth and silence death, the echo trailing into infinity can only be the experience of life, the source of narrative and a pattern for history." Drawing on Louis Chude-Sokei's metaphorical, political, and technopoetic investigations, this volume experiments with how the echo of past ideas of life and form has brought forth the technologies and lifestyles that our contemporary world is based on. The essays, conversations, and artist contributions delineate a variegated array of technologies, creating an image of their past and their future potentials.

Vol. 5: Skin and Code
Editor: Daniel Neugebauer
Contrib.: Alyk Blue, Luce deLire, i-Päd, Rhea Ramjohn, Julia Velkova & Anne Kaun
ISBN: 978-3-95905-461-4

Just as physical violence leaves its marks on the skin, conceptual violence is written into interfaces via algorithms—in the form of biases turned into pixels, as discrimination implanted in memes in secret chat groups. The coding and decoding of body surfaces and interfaces is contingent on a whole host of norms. Yet these are not fixed: rather, they combine to create a matrix of tastes, cultural influences, technical conditions, and physical possibilities. The essays in this volume produce an interdisciplinary noise between surface structures and a selection of cavities: surfaces, skins, and interfaces are injured, gauged, altered, or remedied.

Vol. 6: *Carrier Bag Fiction*
Editors: Sarah Shin, Mathias Zeiske
Contrib.: Federico Campagna, Dorothee Elmiger, Ursula
 K. Le Guin, Enis Maci a.o.
ISBN: 978-3-95905-463-8

What if humanity's primary inventions were not the Hero's spear but rather a basket of wild oats, a medicine bundle, a story. Ursula K. Le Guin's 1986 essay *The Carrier Bag Theory of Fiction* presents a feminist story of technology that centres on the collective sustenance of life, and reimagines the carrierbag as a tool for telling strangely realistic fictions. New writings and images respond to Le Guin's narrative practice of worldmaking through gathering and holding.

ISBN: 978-3-95905-658-8

Spector Books